Yves Saint Laurent
and his dogs

MOUJIK I

HAZEL

Amigos Forever
Collection directed
by Martin Bethenod

Martin Bethenod

Yves Saint Laurent
and his dogs

Norma éditions

Preface

Ever-present in Yves Saint Laurent's life, dogs seem – at first glance – to have been less so in his creations: a couple of outfits in his early career named after beloved dogs; a dog (Moujik II) appearing next to Mounia in a chromatically matching suit on a podium in 1980; silhouettes of bulldogs printed on stylish Rive Gauche dresses; a number of sketches, drawing and drafts, mostly intended for his private circle.

In reality, dogs played a crucial role in Yves Saint Laurent's oeuvre, made all the more interesting in that their presence was expressed through indirect and implicit allusions rather than literal quotations or iconographic uses. The choice of breed (or lack of breed) and name is evidence that they were an underlying backdrop to his life in its private, professional and worldly aspects, as well as to his creativity and thought process.

A Collage of Inspiration, *Un collage d'inspiration* was the title of Pierre Bergé's contribution to the catalog of the 1983 retrospective at the New York Metropolitan Museum of Art: a kind of mishmash (today it would be called a moodboard) of living beings and works that composed Yves Saint Laurent's inner landscape. Only one dog was explicitly featured, sitting on Christian Bérard's lap.

Many dogs are present, however, outside the frames of the portraits assembled in this book. Picasso's 14 dogs, whose story was retraced by Jean-Louis Andral. The Zadig that Proust gave to Reynaldo Hahn. Coco Chanel's dogs, the fox-terrier belonging to Elsa Schiaparelli, Christian's Dior's dog Bobby. Diaghilev's bulldog, as well as Mayakovsky's and Lili Brink's. The dog Moulouk featured in Jean Cocteau's film *The Eternal Return* (even though he was more of a cat person), who spent his life with Jean Marais. Marie-Laure de Noailles's poodle photographed by Dora Maar. Peps, Wagner's Cavalier King Charles spaniel, whose presence helped him write his music, as did Rumpel, Pohl, Robber and Russ… The black-and-white poodles that belonged to Maria Callas, Marlene Dietrich's chihuahuas. Empress Elisabeth of Austria's German mastiffs (and other large dogs). Not to mention the characters in paintings by Velásquez – from *The Meninas* to his court portraits – and Goya – from *The Boy in Blue* to the miserable dog in the *Black Paintings*. And even the stuffed toy dog that Clov and Hamm play with in their dustbins in Samuel Beckett's play *Endgame*.

Dogs and Yves Saint Laurent share an intimate history, but also a cultural one. A history underpinned by a liberal use of references, only decipherable by those who share them, thereby creating a distinction – between those who know and those who do not, i.e. those who are inside the circle and the rest – that is intrinsic to the world of fashion.

Echoing the vignettes in Pierre Bergé's *Collage of Inspiration* for the 1983 exhibition "Yves Saint Laurent: 25 Years of Design" catalog at the Metropolitan Museum of Art in New York, we present, along with their dogs, some key reference points in Yves Saint Laurent's cultural universe.

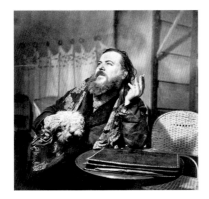

Christian Bérard and his dog

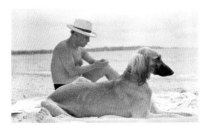

Pablo Picasso and his dog, by Man Ray

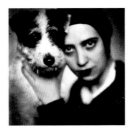

Elsa Schiaparelli and her dog

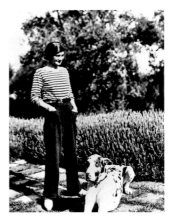

Coco Chanel and her dog

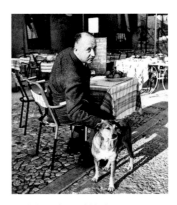

Christian Dior and his dog

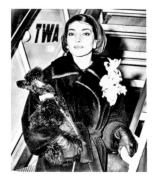

Maria Callas and her dog

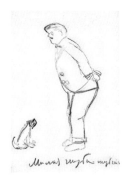

Serge de Diaghilev and his dog, by Michel Larionov

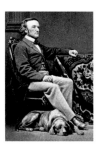

Richard Wagner and his dog

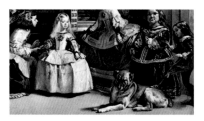

Velázquez's *Meninas* and their dog

Vladimir Mayakovsky and his dog

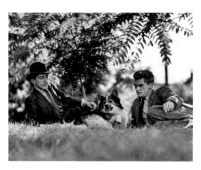

Jean Cocteau with Jean Marais and his dog

Marie-Laure de Noailles and her dog, by Dora Maar

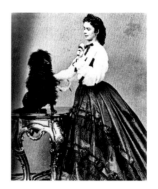

Empress Elisabeth of Austria and her dog

Dog by Goya

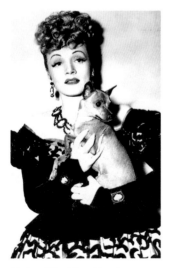

Marlene Dietrich and her dog

Clov, Hamm and their "dog" in *Endgame* by Samuel Beckett

"*I am, as they say, a dog person.*"
(Yves Saint Laurent)

"*My dear little Zadig, listen to this: the small kind of dog that I am is telling you [...] It is only when I have become a dog again, a poor Zadig like you, that I begin to write, and I only like the books written in this fashion.*"
(Marcel Proust, letter to Zadig, Reynaldo Hahn's dog, November 1911)

Fashion has its Golden Legend, and fashion designers, like saints, have their attributes. Dogs are one of these attributes, being one of the most recurring figurative elements in a field dominated by images, from a creator's inner life to the opportunism of publicity. Indeed, there are few professional fields where the presence of a dog is so important to how a man and his profession are represented, and so charged with meaning and emotion, except perhaps for heads of State.

Dogs are there, ever loyal: sitting or standing by Jacques Doucet, photographed by Man Ray in 1926 with his West Highland terrier; by Coco Chanel, with her Great Dane Gigot in La Pausa in 1930 or her two Cavalier King Charles spaniels in Deauville in 1913; by Christian Dior, never without his beloved Bobby; by Hubert de Givenchy, who commissioned Diego Giacometti to sculpt his labradors, dachshunds and greyhounds for the small animal cemetery at the Château du Jonchet. And, more recently, by Azzedine Alaïa, a lover of (very) large and (very) small dogs.

Flou

Dogs were a constant presence in Yves's life, from his childhood in Algeria to his death in 2008, occupying a central role in the Saint Laurent legend fostered by articles, biographies, documentaries, films and museums before being spread to an avid public. The history of Yves Saint Laurent's dogs shows how myths – and their underlying cults – rely on simplification, repetition, fiction... It shows that a legend cannot develop without one crucial element: a certain amount of *flou* (fuzziness).

Everything has been reduced to a single instance, the solitary figure of "Moujik the bulldog", obscuring like a screen across the memory of the other dogs in Saint Laurent's life: the Hazel chihuahuas, and before them the dogs from his childhood to his early Paris years, whose faded memories are often summed up by a single name, like characters in a novel by Modiano – the very writer who gave the following title to the book recounting his youth: *Pedigree*.

The fuzziness was also sustained first of all by Saint Laurent himself, in the chronology and the lack of a precise identification of the successive "Moujiks". Most of the time, all that is remembered is that there were several of them: like a "kind of single dog, a generic dog whose unchanged form received the transmigration of multiple souls," in the words of the philosopher Mark Alizart.

More fuzziness is brought on by the repetition of the same rarely positive anecdotes, which are sometimes marred by contradictions (according to who is telling the story, it was either Hazel or Moujik I who died from a scorpion bite) or errors (Moujik mistaken for a carlin). Or riddled with unfounded details, like the story according to which Yves Saint Laurent did not even

realize when one of his dogs died, for it was immediately replaced with a new one by his entourage. A tale also told about other celebrities, including an Italian fashion designer who owned carlins. Sometimes they are replete with melodramatic visions, fantasies even, like the death of one (unidentified) Moujik from an accidental (undated) overdose during an (unattested) sex party.

Youth

Over 30 years before the adoption of Moujik I, dogs were already part of the family environment, as is attested by photographs from vacations during the 1940s, peopled with charming two-colored mixed-breeds. On one black-and-white image, Lucienne Mathieu Saint Laurent, wearing a short skirt, is sitting on the edge of a basin, her two daughters standing by her side (ill. p. 14). Clasped to her bosom is a little white dog, a Barbet or a Bichon Frise. With water up to his knees, a preadolescent Yves Mathieu Saint Laurent is standing behind his mother and hugging her with her long arms. He is wearing a swimming costume, in a kind of "fin de siècle Taormina" *contrapposto* stance. North Africa, his relationship with his mother, the ambiguous aestheticism… many elements of the legend were already in place, so dogs had to be there too.

During his youth, dogs were also present in the Oran landscape and the artistic world of the budding creator. In an interview with *L'Écho d'Oran* in 1957, cited by Laurence Benaïm in her reference biography, Saint Laurent mentions his love of "those hideous but very kind dogs – the abandoned ones. I take them in, but they are always already so old that there is not enough time to enjoy their stay."

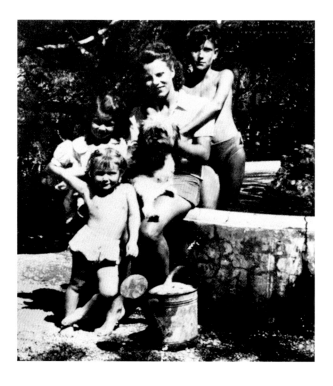

Yves Saint Laurent, his mother, his sisters and a dog, Algeria, late 1940s

Touching words, wherein one might detect, behind the sincerity of the statement, a reminiscence of Baudelaire, whose works were always present on his bookshelves: "The poor dogs, the dirty dogs, the ones everyone kicks aside like flea-ridden plague sufferers, except the poor man who is their associate, and the poet who looks upon them with a fraternal gaze" (*Les Bons Chiens*, 1866). A brotherhood of outcasts, a disgust for the bourgeoisie (his famous "I hate bourgeois women, their spirit, their intransigence, their taste" in the 1968 interview with *Dim Dam Dom*). The legend unfolds.

This was also the time of his admiration for Jean-Gabriel Domergue (did he know about his portrait of the Pekinese Ku-Zee, or his *Femme aux lévriers* ("Woman with greyhounds")?) and for Marcel Vertès, who filled his illustrations for Vamp stockings with Scottish Terriers and Afghans. Above all, it was the time when he discovered the revelatory work of Christian Bérard. When the Comédie-française performed *L'École des femmes* by Molière in Oran in 1950, with Bérard designing the set and costumes, it was a foundational aesthetic shock, and Bérard's influence would cut deep. His drawings – some representing cute dogs (ill. p. 16) – strongly impacted Yves Saint Laurent's early ones (ill. p. 17). As did his way of displaying his homosexual couple even in the most upper-class circles. And the constant presence of his dog, the shaggy Jacinthe, by his side – they can be seen together at the Dior fashion show in 1947.

He carried these memories with him upon arriving in Paris in 1954, when he began working for Dior. Especially the memory of the little dog Zouzou, whose photograph he kept for a long time by his desk. As he explained in an interview with the ORTF in 1959, he named a suit – gray like she was – after her for the 1957 Dior collection. He did likewise with Hazel – the first mention of a name which would come to mean a great deal in the two following decades – and Bobby, following the example of Christian Dior himself, whose "tailleurs Bobby" were a resounding success during eight whole seasons.

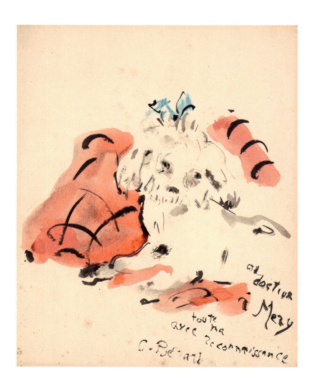

Page 17

Christian Bérard, Petit chien ("Small dog"), oil and pastel, n.d.

Yves Saint Laurent, early drawing, oil pastel, watercolor, brush and ink on paper, n.d.

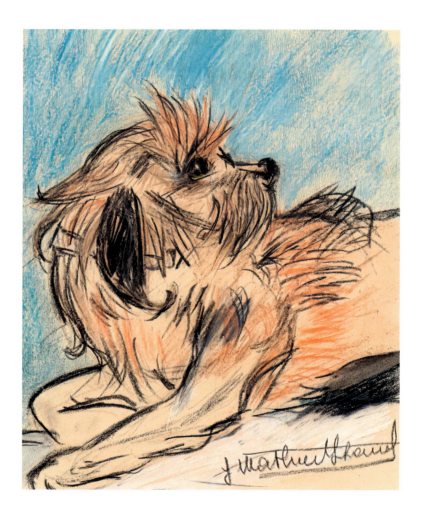

In 1962, a dog accompanied the Saint Laurent family when they moved back to Paris. As he said later to Yvonne Baby in 1983: "I will always remember the poignant image of my mother and sisters in Paris, in a tiny room I had rented for them, after they had just arrived with their dog." Was this Bobinette, a name according to Marie-Dominique Lelièvre? Or Bribri, as was related by Marianne Vic, who informs us that the name was also the name of her own mother Brigitte, sister of Yves and daughter of Lucienne Mathieu Saint Laurent? Whatever the case, all her life Lucienne kept her Pekinese (Noba) or her shih tzus (Filou) close by. Dogs would always remain an inexhaustible topic of conversation between mother and son, at Sunday lunches in Rue de Babylone.

Hazel

The decade of the 1960s was centered around Place Vauban, where the Pierre Bergé–Yves Saint Laurent couple lived from 1961 to 1972. Frica, a pretty black and tan dog, a kind of Pinscher Dobermann, makes a notable appearance on photographs by Robert A. Freson, who learned the art of portraiture under Irving Penn. Frica can be seen either walking about on a leash or calmly sitting at his master's feet, who is flicking through an art book in the drawing room where there hangs a painting that was always treasured by Saint Laurent. Neither a Goya nor a Picasso, it would still follow him everywhere, and portrays a 19th century notable accompanied by his dog. Like a character from a Stendhal or a Flaubert novel, he is actually Saint Laurent's ancestor Laurent Mathieu, Baron de Mauvières, whose family history informs us that he presided at Napoleon and Josephine's wedding.

Page 19

Yves Saint Laurent and Frica, under the portrait of Baron de Mauvières and his dog, Place Vauban flat, Paris, 1964. Robert A. Freson photography

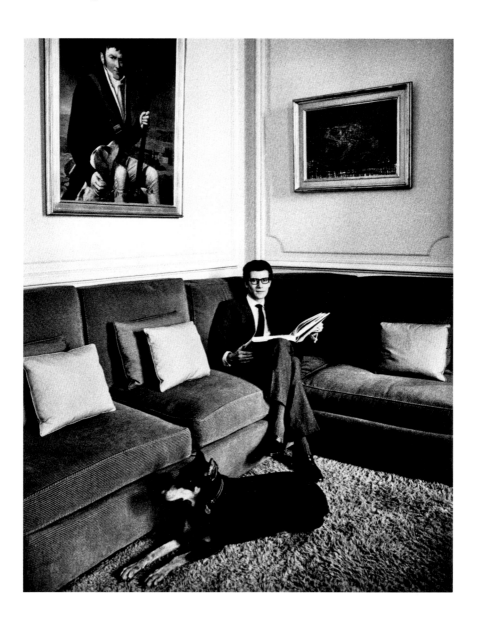

SOCIÉTÉ CENTRALE CANINE

pour l'Amélioration des Races de Chiens en France

FÉDÉRATION OFFICIELLE FRANÇAISE DES SOCIÉTÉS ET CLUBS AFFILIÉS
RECONNUE D'UTILITÉ PUBLIQUE

3, Rue de Choiseul - PARIS (2e)

LIVRE DES ORIGINES FRANÇAIS
(L. O. F.)
1882

Inscrit au Registre des Livres Généalogiques du MINISTÈRE de l'AGRICULTURE FRANÇAIS

PEDIGREE

(doit obligatoirement être remis en même temps que le chien en cas de changement de propriétaire)

Nom du Chien : ISA
Race : CHIHUAHUA
Sexe : Femelle Né le : 15 SEPTEMBRE 1959
Producteur : Monsieur BERGE

Délivré à Paris, le 20 NOVEMBRE 1959
Le Président de la S.C.C.

NOM DU CHIEN
ISA

S. C. C. contrôle 191949

à envoyer à la S.C.C.

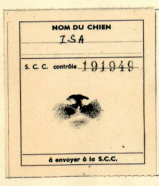

29.
9. Chi.
30.11.59

The chihuahuas called Hazel then began their reign. They followed after Chocolate Drop, whose prestigious pedigree was attested by London's Kennel Club, and who was registered at the LOF in 1958. Her master Mr. Pierre Bergé lived in Rue Saint-Louis en l'Île, and she was the happy mother of a litter comprising four puppies (Igor, Ines, Isa and Isold) born in 1959 from one Mi Amigo, whose ascendency was just as impeccable.

In the early 1960s, chihuahuas were associated with glamor, but also with ambiguity and transgression. Their masters were Marlene Dietrich, who inspired the first tuxedo in 1966; Coccinelle, the first French transgender star; and Jayne Mansfield, who once said that she wanted "ten more chihuahuas and a few Academy Awards." The name Hazel was derived from a character in an American comic book that had existed since the 1940s, and that was made into a cult TV show featuring Shirley Booth. Photographed in a studio on Madame Ida's lap in 1966, the year the collection inspired by pop art and Wesselmann was launched, Hazel attested to the increasing influence of American mass culture on the inspirations of the 60s.

Above all, it attested to the importance of the notion of "camp," theorized by Susan Sontag in 1964. What better dog than a chihuahua, associated with the memory of both Gertrude Stein (Pepe) and Marilyn Monroe (Choo Choo), to embody camp? This particular style, which combined genre-blurring, irony, pastiche, the meeting of the grotesque and the snobbish, and the stupid and the cerebral, was a keystone of the cultural, intellectual and worldly environment in which Yves Saint Laurent and his entourage were immersed throughout the 1960s and 1970s.

Page 20

Pedigree of Isa, daughter of Chocolate Drop,
Pierre Bergé's first chihuahua, 1959

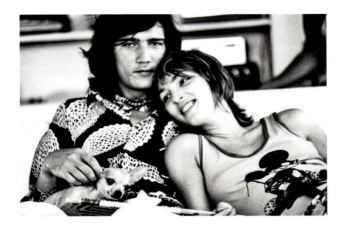

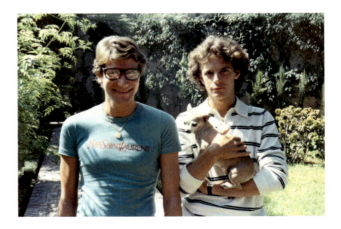

Talitha Getty, Maurice Hogenboom and Hazel, Marrakech, 1970s

Yves Saint Laurent, François-Marie Banier and Hazel, Marrakech, 1970s

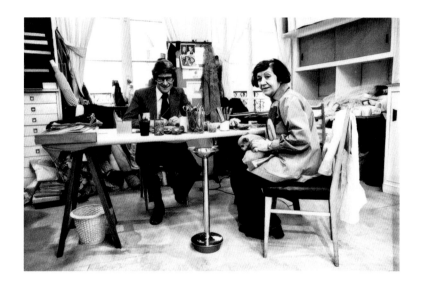

Yves Saint Laurent, Ida Fayolle and Hazel,
30 bis rue Spontini, Paris, 1966

Hazel is, or rather Hazels are, since there were several, one of the great omissions in the Saint Laurent legend. For the Hazel years lasted at least two decades, from the very end of the 50s (one cannot exclude the possibility that Hazel was a rechristened daughter of Chocolate Drop, Pierre Bergé's very first chihuahua) to the early 80s. From Rue Spontini (and even before) to Avenue Marceau, from Place Vauban (and even the Ile Saint-Louis) to Rue de Babylone, they were brilliantly captured in various photographs. Hazel in Marrakesh with Talitha Getty or in the arms of François-Marie Banier (ill. p. 22). Hazel by Alice Springs, by Martine Franck. Hazel in Saint Laurent's arms, hiding in his jacket like a lapdog in the folds of a Chinese dignitary's dress, Hazel huddled in his lap during the 1977 Anthony Burgess interview…

Those who knew her all remember her aggressive nature. She is even said to have tried to bite Maria Callas once – an absolute sacrilege! As Yves Saint Laurent was warning her against Hazel's character, La Divina answered haughtily: "Nobody resists Maria Callas!" Before quickly backing away to avoid the yappy dog. Whether authentic or not, the anecdote does reveal an essential aspect of these dogs for Yves Saint Laurent: they embodied regression, irreverence, dirtiness and chaos in a world full of devotion, perfection and self-control. Like Loulou de La Falaise later told Laurence Benaïm: "Yves has an unexpectedly mucky side. He draws, the dog pisses. He is not at all bothered by the mess."

Page 25

Yves Saint Laurent and Hazel,
30 bis rue Spontini, Paris, 1968.
Martine Franck photography

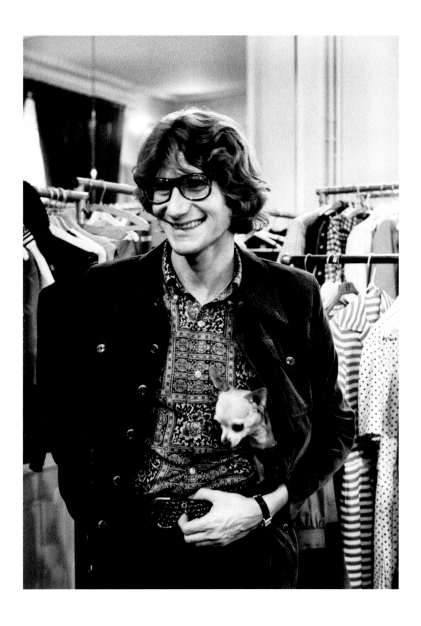

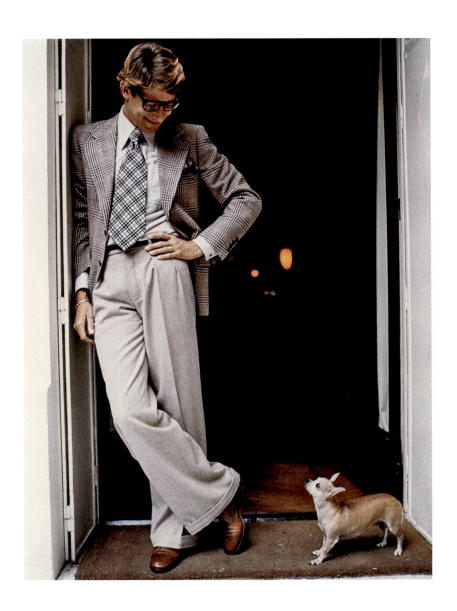

This maliciously impish role was personified by *Vilaine Lulu* (ill. pp. 30—31) from the late 1950s, followed by the comics in which she was the heroine. Lulu, whose name echoes that of Yves's mother Lucienne and whose hairstyle and boater recall Coco Chanel, was a figure of disorder, cruelty and sadistic urges. As her companion she had not a dog, but a rat: how could one not think of Freud's "Rat Man," a figure of "obsessional neurosis" and closeted homosexuality, or of the sadomasochistic practices that dark rumors ascribe to Marcel Proust – as they later did to Saint Laurent himself?

Like Lulu but in a milder, more socially acceptable register – with its own share of naughtiness, often practiced with Betty Catroux, a companion in childish tricks who even earned the nickname Pulu –, dogs exemplified resistance to the adult world. According to Alicia Drake, "It was at this time [1970] that people saw couples being divided into two separate camps, the 'adults' and the 'children.' The adults, led by Pierre Bergé, dealt with practical issues and took on daily responsibilities. The others, grouped around Yves, celebrated fancy and thumbed their noses at reality." One could rather say: around Yves and his dogs.

Page 26

Yves Saint Laurent and Hazel, Paris, 1973.
Roger Gain photography

Yves Saint Laurent and Hazel,
Rue de Babylone flat, Paris, 1970s

Pages 30—31

Plate "Une belle histoire d'amour"
from the luxury edition of *La Vilaine Lulu*,
Tchou editions, 1967

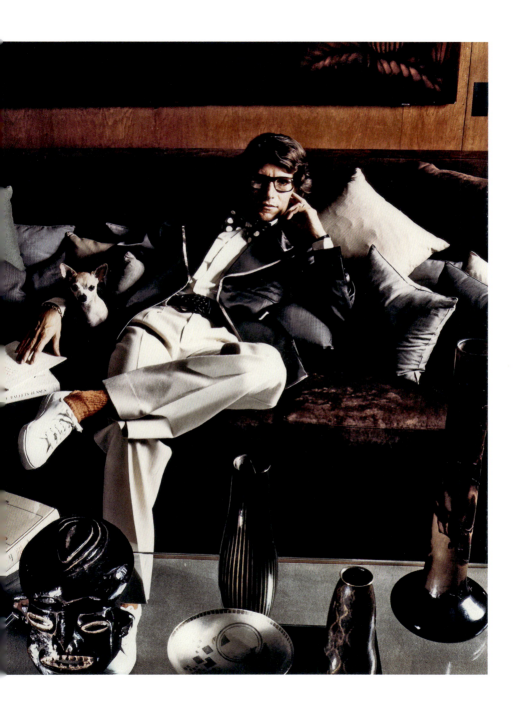

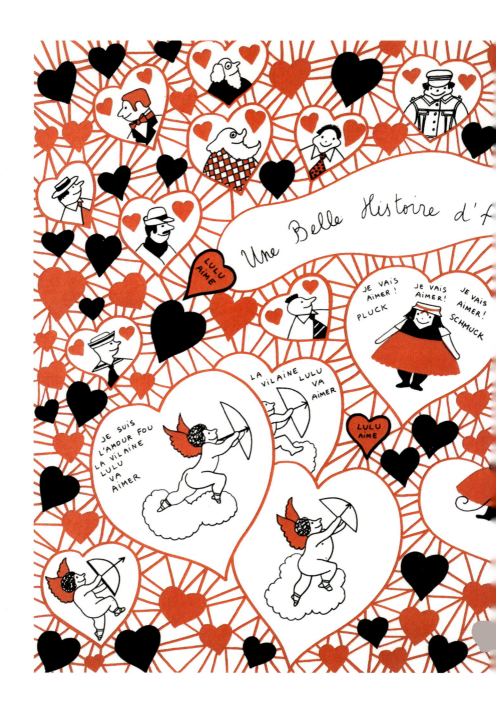

Moujik

Hazel was still there, and still biting, even though by the time Moujik arrived in 1975-1976, the first of four, she was getting a bit tired. She would also live with Moujik II until his death in 1982. Like the first chihuahuas, Moujik started off with Pierre Bergé as his master. This is attested by the pictures taken by Patrice Habans on 5 Avenue Marceau, with Hazel on one side in Saint Laurent's arms, and Moujik on the other, standing guard by Bergé's desk (ill. pp. 34—35).

For Pierre Bergé was also a dog lover, from the ones he had owned during his time in Provence with Bernard Buffet during the 1950s, to Ficelle, the Jack Russell, and Echo, the Shiba Inu, his final companion, whom he had brought back from New Jersey by the essential Connie Uzzo. The dogs, whether real or in an artistic representation, played multiple roles in the relationship between Bergé and Saint Laurent: the emissary of private exchanges (like Reynaldo Hahn's dog Zadig, to whom Proust used to write in order to send messages to his master that he could not phrase explicitly), but also the subject of rivalries to be snatched (Moujik I was appropriated by Saint Laurent) or given away (Hazel, who ended her life with Bergé). Not to mention roles as gifts, a major ritual in the intimate, friendly and professional life of the Bergé—Saint Laurent couple. "Moujik by Andy was the most wonderful Christmas present I could hope for," Saint Laurent wrote when Pierre Bergé gave him Andy Warhol's portrait of Moujik II in 1986.

Page 33

Moujik I and Hazel, Marrakech, 1976—1978

Page 34

Pierre Bergé and Moujik I, Pierre Bergé's office, 5 Avenue Marceau, Paris, 1978.
Patrice Habans photography

Page 35

Yves Saint Laurent, Hazel in his arms, and Moujik I, 5 Avenue Marceau, Paris, 1978.
Patrice Habans photography

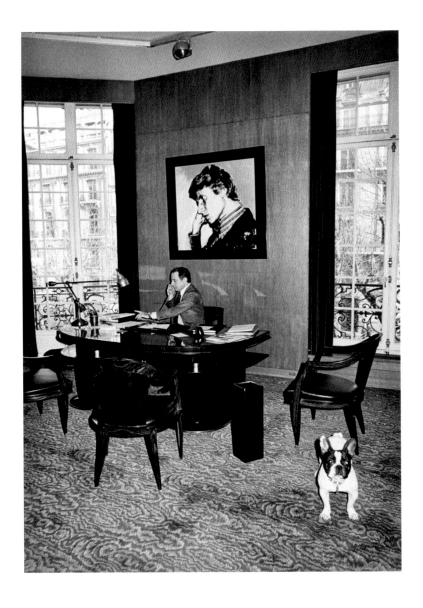

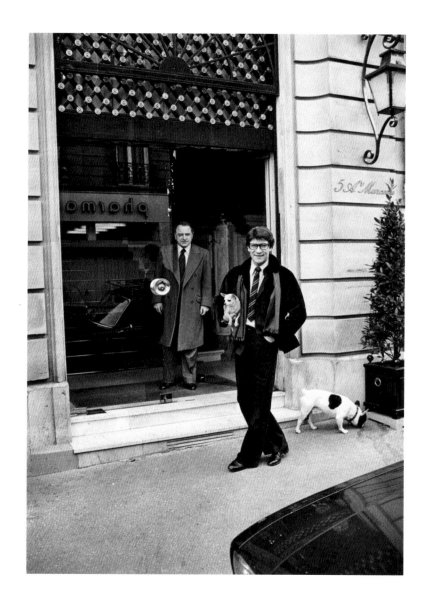

Like the three that followed, Moujik was a French bulldog with a "caille" coat (meaning, in the coat's official definition, "brindle with white spots ideally scattered across the whole body"). Unlike the chihuahua's American style, the bulldog's heritage clearly stemmed from the old world. It blended aristocracy – like Peter, Edward VII's bulldog – and artistic avant-garde – like Bouboule, sketched by Toulouse-Lautrec and belonging to Madame Palmyre, who received Renée Vivien, Natalie Clifford Barney and of course Colette in her cabaret. Nobody knew how to evoke or describe these dogs' unique characteristics better than Colette: "I do not want a dog, I want a bulldog. A bulldog with one eye here and one there, far apart from each other, and the broad forehead of a thinker, no nose or barely, a nice thick neck, their head in their shoulders. You know, a bulldog!"

It was during the late 19th century in France and England that French bulldogs were stabilized as a breed, but they quickly met with great success in Russia: the Grand Duchess Tatiana was followed into exile by her loyal Ortino; Diaghilev was drawn with his dog by Michel Larionov; and, last but not least, Mayakovsky, who kept Boulka by his side until the day he committed suicide on 14 April 1930. When Moujik came into the world of Yves Saint Laurent and Pierre Bergé, he carried this cultural heritage with him, putting the Hazels' pop and camp style out of fashion in an instant.

Page 37

Vladimir Mayakovsky and Bulka, late 1920s

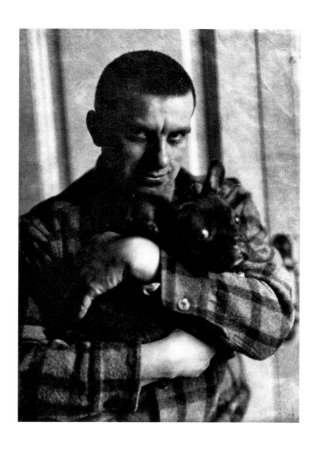

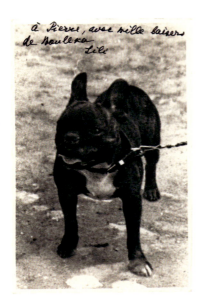

à Pierre, avec mille baisers
de Bouleka
Lili

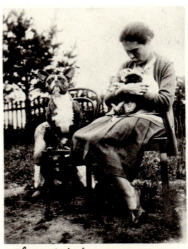

Le mari de Bouillpa et
ses enfants
Lili

In 1976, Yves Saint Laurent presented the Russian collection, which the *New York Times* called "a revolutionary collection that will change the course of fashion around the world." A few months previously, the Mayakovsky exhibition at the CNAC in Rue Berryer (an early version of the future Centre Pompidou) had been one of the great cultural events of the 1975 season. Lili Brik, who had been the poet's partner and muse, had become friends with Bergé (he later wrote that she and her sister Elsa Triolet "combined culture, beauty, talent, and intellect. They were unbeatable") and with Yves Saint Laurent. He gave her a dress for her 85th birthday in 1976. And it was she that gave the little bulldog its name, no doubt in reference to Mayakovsky as much as to Turgenev, the author of one of the most famous and heart-rending dog stories in all of Russian literature, about the moujik Gherasim and his dog Mumu.

"Moujik was named by Lili Brik, who lived with Mayakovsky and had a decisive influence over the Russian poet. Lili has since died, but Moujik is still there, very alive," Yves Saint Laurent wrote in 1987. One remarkable detail is that if Moujik I was indeed named by Lili Brik, he died in 1978 – stung by a scorpion, according to legend and several authors, in Dar Es Saada, the "house of joy in serenity." The one who was there and very alive in 1987 was already Moujik II (1979–1990). And there we are again, in the fuzzy realm of legend.

Page 38

Photographs of Bulka, her puppies
and their father, presented to Pierre Bergé
by Lili Brik in 1976–1978

Collection

In order to identify the Moujiks that followed each other over 40 years until 2016, for lack of verified accounts and documents – all the more incomplete in that the puppies were often renamed, so they are registered at the Central Canine under a different name; for instance, Moujik III was born Gaiac, in Clamart in July 1991 – the surest way is to study their coats.

MOUJIK I

Moujik I, adopted during the mid-1970s – long before the fashion for bulldogs met with a revival in the 1980s, they having lost favor at the end of World War Two – has a white spot on his (black) right ear, a large black oval-shaped spot on the back of his right flank, and a smaller, round black spot at the front of his left flank, as is clearly visible on photographs from 1978 where he is "helping" Pierre Bergé and Yves Saint Laurent to study architectural plans with Hazel.

Page 41

Yves Saint Laurent, Pierre Bergé,
Hazel and Moujik I (left flank / right flank),
5 Avenue Marceau studio, Paris, 1978.
Patrice Habans photography

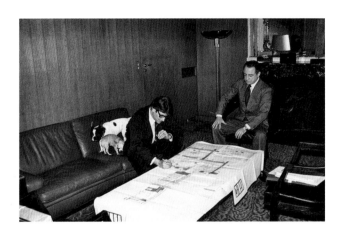

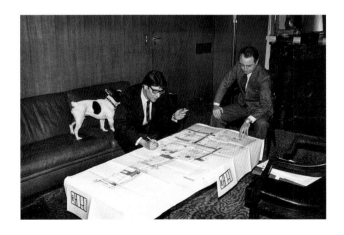

MOUJIK II

Moujik II appeared in a photograph for the first time wearing a bright red frilly dress, on a Polaroid taken in the studio during preparations for the 1979 fall-winter collection. His ears, entirely black, are recognizable, as well as his slightly asymmetrical muzzle (whiter on the right side compared to the left) and his four conspicuous black spots: one large round spot on his back; a smaller one right by the first, on the right flank; one large spot at the top of the left front leg; and a small round spot on his hindquarters, around the tail. Along with Moujik III, who was also sacrificed to the Polaroid ritual in 1991 and is wearing a small black dress, they are the two most represented, photographed, drawn, and cited dogs in the whole collection.

It was Moujik II who had his portrait done in 1986 by Andy Warhol, in red, blue, green and white (ill. pp. 44—45) - as he had done Yves Saint Laurent's 14 years earlier. The quadruple portrait later occasioned another small historical leap (more fuzziness). In 1994, Saint Laurent told Edmund White, who had come to interview him for the *Sunday Times*: "Warhol? The last thing he painted was my dog Moujik. Then he died." Indeed, Warhol's death on 22 February 1987 occurred only a few months after he had painted the portraits in the fall of 1986, but these few months left enough time for the prolific artist to create other, later works... Warhol's *Moujiks* were also reappropriated by Saint Laurent, who used them for his 1991 greetings card "Love."

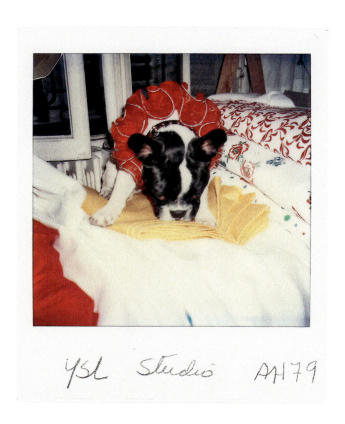

Moujik II, Polaroid taken by the fashion
house staff, 1979

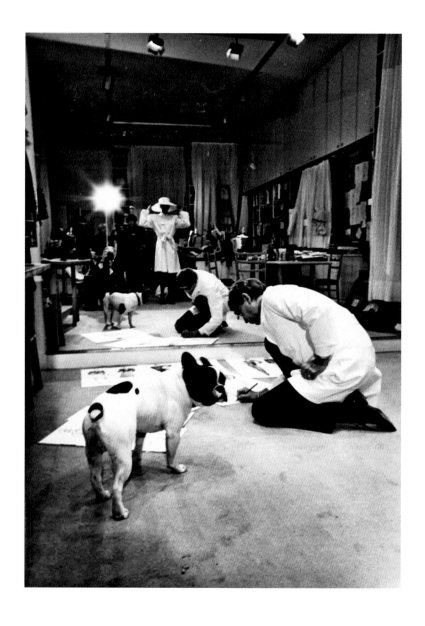

45

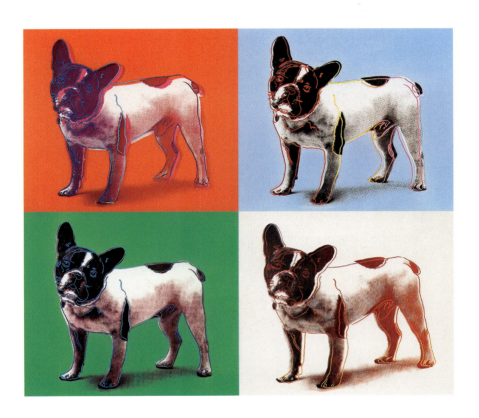

Page 44

Yves Saint Laurent and Moujik II,
5 Avenue Marceau studio, Paris, 1982.
Pierre Boulat photography

Moujik III by Andy Warhol, 1986,
gift from Pierre Bergé to Yves Saint Laurent
for Christmas 1986

An intimidated Moujik II was also paraded for Rive Gauche in 1979 with Mounia, in a matching black and white suit – no images exist, however, of his alleged participation in the famous Broadway Suit fashion show in 1978, as mentioned by some. He also posed with his master in the Majorelle Garden (ill. p. 48), on the green carpet of the Avenue Marceau staircase (ill. p. 49), and in 1983 in a hotel bedroom in New York (ill. pp. 50—51), on a bed strewn with newspapers whose headlines are celebrating the Metropolitan Museum exhibition's triumph. He also inspired aphorisms – "Moujik hates trouser-wearing women" – declarations of love – "Moujik my passion" – in the great interview with Égoïste from 1987, or collages – "Moujik above all" – on a sketch for an evening dress from 1985 (ill. p. 54).

Page 47

Mounia Orosemane and Moujik II,
SAINT LAURENT *rive gauche* fashion show
spring-summer 1980, Paris, October 1979

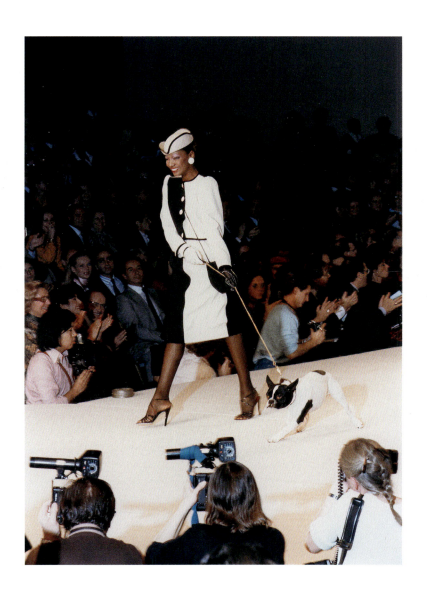

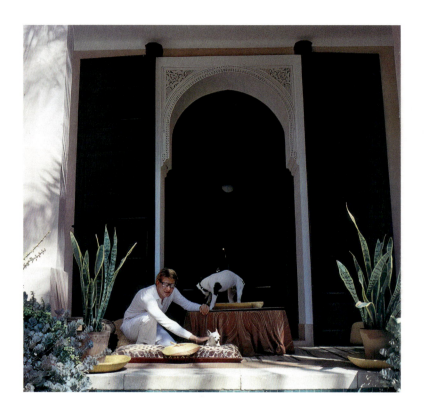

Yves Saint Laurent, Moujik II
and Hazel, Marrakech, 1980.
Horst P. Horst photography

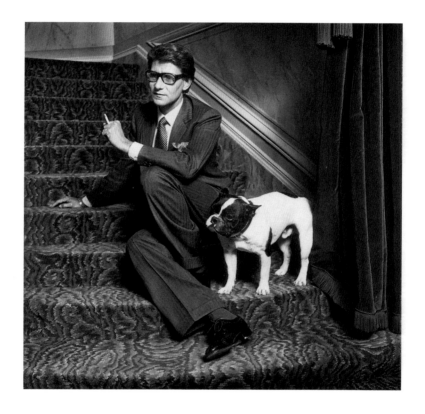

Yves Saint Laurent and Moujik II,
8 Avenue Marceau staircase, Paris, 1982.
Bettina Rheims photography

Yves Saint Laurent and Moujik II
in New York at the opening of the
Metropolitan Museum exhibition, 1983.
Jean-Claude Deutsch photography

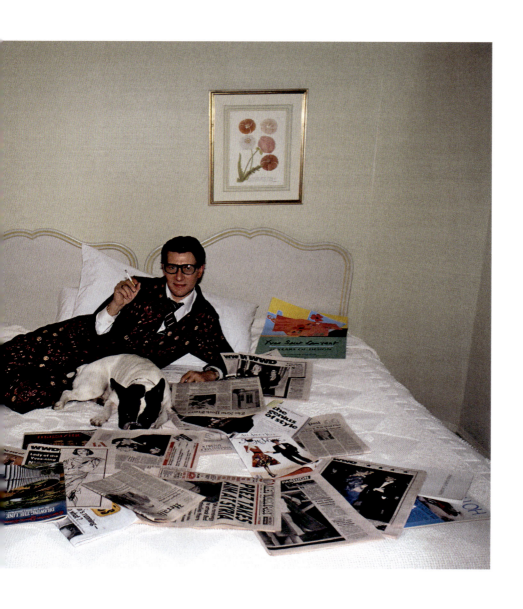

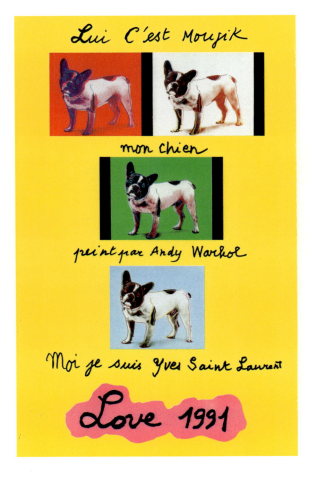

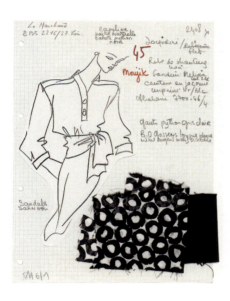 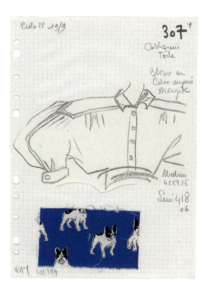

Page 52

Yves Saint Laurent, "Love" greetings card (with Moujik II), 1991

Left image:

Yves Saint Laurent, worshop sheet known as "Bible" for the Moujik dress in the Haute Couture 1986 spring-summer collection, printed paper pasted on paper, annotations in graphite pencil and sewn textile sample

Right image:

Yves Saint Laurent, worshop sheet known as "Bible" for a blouse in the SAINT LAURENT *rive gauche* 1987 spring-summer collection, printed paper pasted on paper, annotations in graphite pencil and sewn textile sample

54

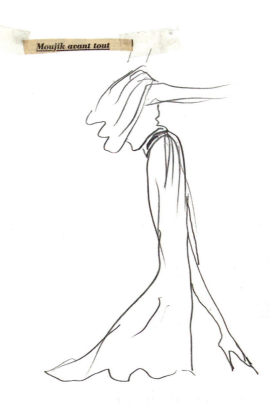

Moujik avant tout

MOUJIK III

Less than for the two large spots on his back and hindquarters, Moujik III is easily identifiable by his coat, nearly speckled in places. Although Moujik II was the most photographed, Moujik III would be the most captured on camera, especially in the documentary *Célébration* by Olivier Meyrou, filmed over 18 months, that the public only discovered in 2018, 20 years after the shoot.

Moujik is nearly always there, during long stretches of boredom, work and silence, playing with plastic water bottles during the extremely ritualized preparatory sessions for the collection in the Avenue Marceau drawing room (ill. pp. 56 to 62). Although not always seen, he is always present off-screen (the voice of Loulou de La Falaise can be heard: "What are you doing, Moumouj?" before he enters), in the restless, whispering studio captured during working hours by David Teboul in 2002 in *Yves Saint Laurent, 5 avenue Marceau 75016 Paris*.

Page 54

Yves Saint Laurent, original sketch
of a dress from the Haute Couture
1985 spring-summer collection, graphite
pencil on paper

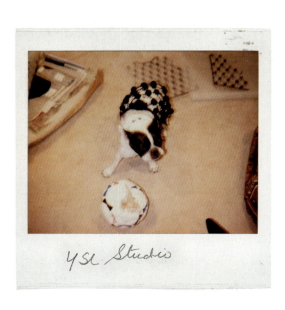

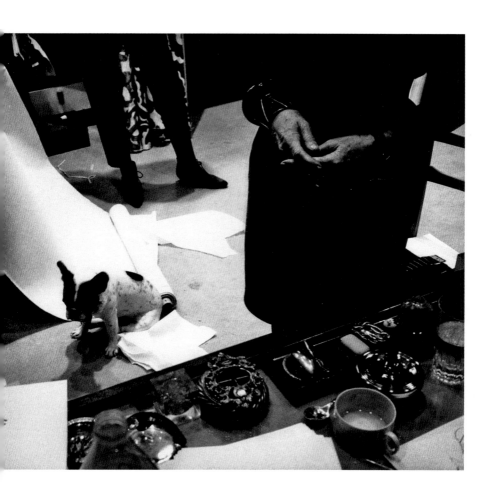

Page 56

Moujik III, Polaroid taken by the fashion house staff, 1998

Moujik III, during preparations for the 1992 spring-summer fashion show, 5 Avenue Marceau, Paris

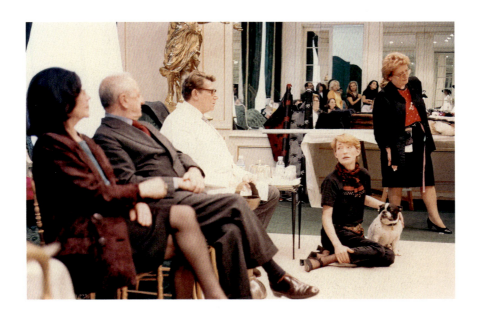

Anne-Marie Munoz, Pierre Bergé,
Yves Saint Laurent, Loulou de La Falaise
with Moujik III, Madame Renée,
5 Avenue Marceau living rooms, 1998.
Thierry Chomel photography

Page 59

Yves Saint Laurent, Moujik III
and Aga Cupial wearing a dress from
the spring-summer 1998 Haute Couture
collection, 5 Avenue Marceau studio, Paris,
1998. Alexandra Boulat photography

Pages 60—61

Preparations for the final fashion show
at the Centre Pompidou on 22 January 2002.
Yves Saint Laurent with Monsieur
Jean-Pierre, Amalia Vairelli and Sabrina
Magalhaes, in *Yves Saint Laurent, 5 avenue
Marceau 75016 Paris* by David Teboul, 2002.

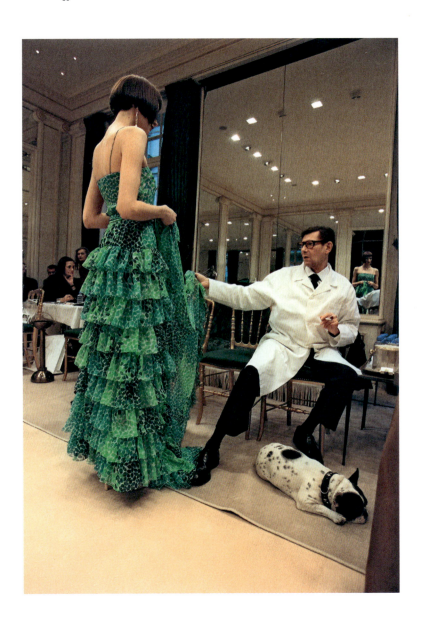

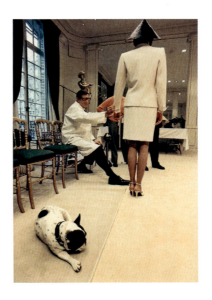
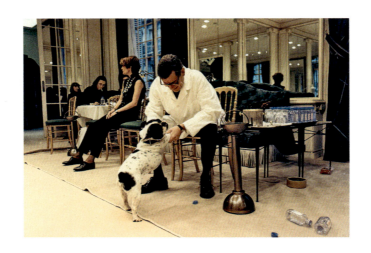

Moujik III was also granted his own "Love" greetings card in 2002 (ill. p. 64). This time, it was not the portrait of a jetset dog elevated by Andy Warhol to the status of work of art, but the roughly cut out image of an aged one. Moujik was getting older, completely indulged by his master (indulgence was his favorite quality among men and women, according to his answer to his Proust Questionnaire). Saint Laurent encouraged his tendency towards jealousy and aggressiveness: Japanese ladie bitten in the street, visitors assaulted on Avenue Marceau, a diner at the Hôtel Costes who asked Pierre Bergé to pay her back for a pair of tight-fitting leather pants – not at all the style of the house – ripped to shreds by Moujik's fangs. He encouraged his gluttony as well, especially his penchant for ice cream, that he had served to him by his maître d'hôtel in a Compagnie des Indes plate. Kafka's lines in *Blumfeld, an Elderly Bachelor* spring to mind: "The day comes when you look into the eyes of the dog, and your own old age looks back, in tears."

When Moujik III died, a devastated Yves Saint Laurent swore he would never want a dog ever again. In one final attempt to console him, Pierre Bergé went to the pet store on Quai de la Mégisserie and brought back a puppy that he found adorable despite his imperfect pedigree – and tolerance to imperfection was not reputed to be his most defining personality trait.

Page 62
top left image

Yves Saint Laurent, research sketches for the Mode collections, late 1990s, graphite pencil on paper

Page 62
top right image and bottom image

Preparations for the fashion show at the Stade de France, 5 Avenue Marceau living rooms, 1998. Alexandra Boulat photography

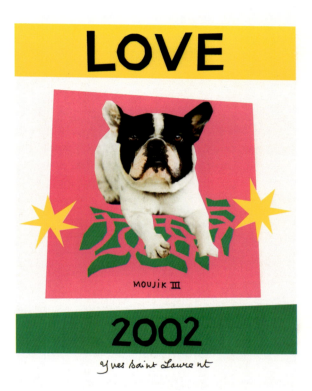

Yves Saint Laurent, "Love" greetings card (with Moujik III), 2002

Page 65

Yves Saint Laurent and Moujik during preparations for the final fashion show, 5 Avenue Marceau offices, 2002. Alexandra Boulat photography

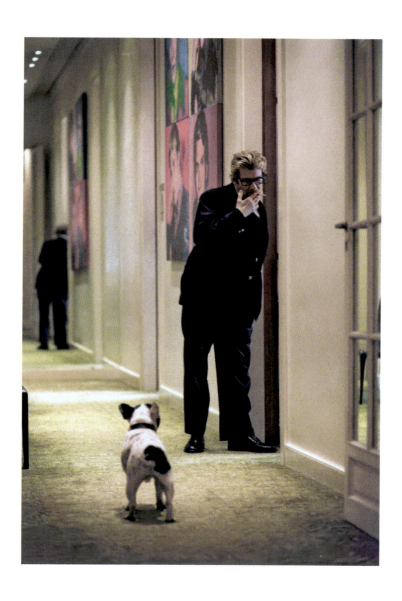

MOUJIK IV

This was Moujik IV, characterized by his wide white stripe and a single large black spot on his right flank. During the 2006 New Year, he was the third Moujik to be the subject of a "Love" greetings card, swathed in ribbons, full of spry charm and youthful naivety. Later on, in 2010, he had his portrait done by David Hockney (ill. p. 69). From Paris to Tangier, he accompanied his master everywhere, right up to Saint Laurent's death, outliving him by seven years.

Luc Castel's photographs of this little dog, alone in Babylon, as works were being removed in preparation for the dissemination of the fabulous Bergé-Saint Laurent collection by Christie's in February 2009 (ill. p. 71), encapsulated the end of an era. His image would also be chosen by Christie's to illustrate the pass for guests of honor during the once-in-a-century sale (ill. p. 70). Which was fitting, as many dogs were present, from the little black and white Spanish dog on Goya's *Boy in Blue* to the spaniel from Pieter de Hooch's *Young Woman* to the automatic carriage clock (Augsburg, first quarter of the 17th century), the agate snuffbox (Dresden, 1750) in the shape of a pug, or Pompon's 1930 *Boston terrier*. Dogs from art, dogs from life.

Page 67

Yves Saint Laurent, "Love" greetings card (with Moujik IV), 2006

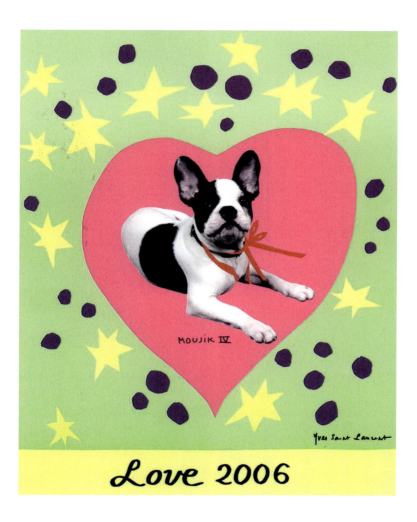

Page 68

Moujik IV and the Sénoufo
bird, Rue de Babylone, 2009.
Luc Castel photography

Page 69

David Hockney, *Moujik*, 2010, iPad drawing
printed on paper, Edition of 25

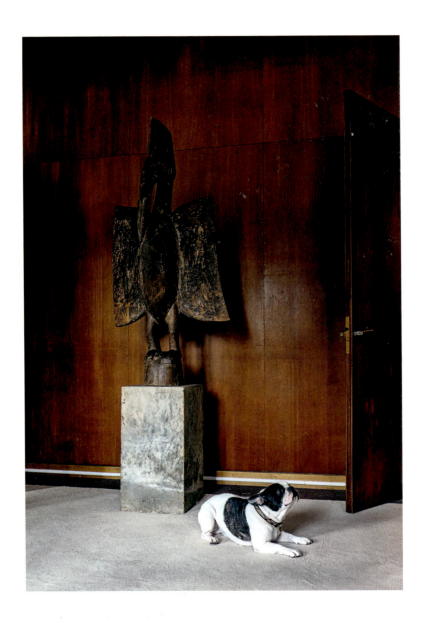

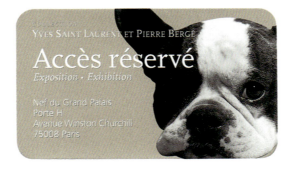

Page 71

Access badge reserved for guests of honor at the Yves Saint Laurent and Pierre Bergé collection sale by Christie's, Grand Palais, 2009

Moujik IV, as works are being packed for the Yves Saint Laurent and Pierre Bergé collection sale, Rue de Babylone, 2009. Luc Castel photography

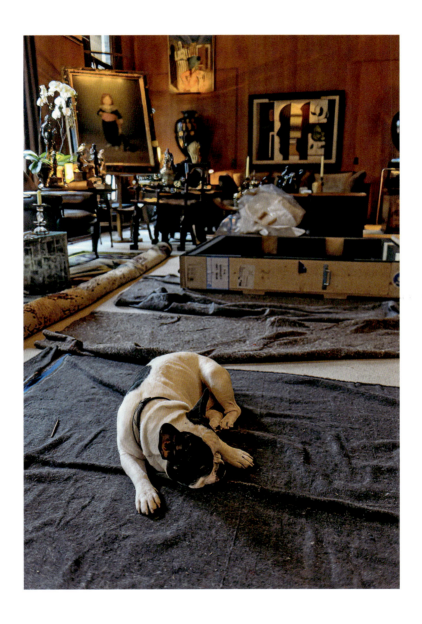

Moujik carried on living until 5 March 2016. He was the last in the line of bulldogs about whom Colette – who better to conclude this little book? – wrote in *De la patte à l'aile*: "They are poor little monsters, too smart, nervous and jealous, as fearful as island birds." These little dogs therefore also belong to the family of sensitive individuals, "that magnificent and pathetic family which is the salt of the earth," from which Yves Saint Laurent would borrow the association with Proust when he bid farewell to fashion, creation andthe world, on 7 January 2002.

Page 73

Francisco de Goya y Lucientes, *Portrait of Luis María de Cistué y Martinez* (or *The Boy in Blue*), 1791, Yves Saint Laurent and Pierre Bergé collection, donated by Pierre Bergé to the Musée du Louvre in 2009

Pages 74 and 75

Handwritten note by Yves Saint Laurent about his fetishes and lucky charms, published in issue no. 10 of *Égoïste* magazine, 1987

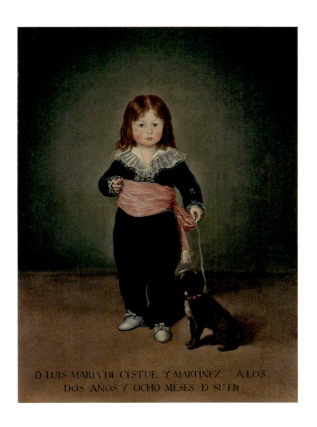

Le Blé porte Bonheur
Les Lys, ma fleur favorite
Une Venus de Bronze, symbole
de mon métier et passion des Bronzes
A la recherche du Temps
perdu de Proust. ~~Les~~
~~Mardis~~ Depuis l'âge
de 15 ans je ne cesse de
relire cet oeuvre inégalable

Les obélisques et la Boule
de cristal de Roche parce
que je suis fou de cristal
de Roche

Une Croix XVIIème ayant été
partenu à Mademoiselle
Chanel
un Lion, mon signe.
un jeu. Le Solitaire ~~en~~ je
suis souvent seul

La photo de mon chien,
ma passion Moujik

Le 10 de trèfle une carte
trouvée dans les caves de
ma première maison de
couture Rue Spontini. La
seule qu'il y avait.
Je suis très superstitieux

Mes lunettes et le Temps
retrouvé que je n'ai jamais
voulu lire parce que je me
dis que si je termine la
Recherche quelque chose
en moi sera brisé

Mes Crayons.

Yves Saint Laurent's dogs

Bobinette	p. 18
Bribri	p. 18
Frica	p. **19**
Gaiac (Moujik III)	p. 40
Hazel	p. 12, 15, 21, **22**, **23**, 24, **24**, 27, **27**, **28**, 32, **33**, **35**, 36, **41**, 48
Unknown	p. 13, **14**, 18
Moujik I	p. 13, 32, **33**, **34**, **35**, 36, 39, 40, **41**
Moujik II	p. 5, 32, 39, 42, **43**, **44**, **45**, 46, **48**, **49**, **50-51**, **54**, 55
Moujik III	p. 40, 42, 55, **56-62**, 63, **64**, **65**, 76
Moujik IV	p. 66, **67-71**, 72
Zouzou	p. 15

Dogs in his orbit

Bobby	p. 6, 7, 11, 15
Bouboule	p. 36
Boulka	p. **37**, **38**
Chocolate Drop	p. 21, 24
Choo Choo	p. 21
Filou	p. 18
Gigot	p. 7, **11**
Igor, Isa, Ines, Isold	p. **20**, 21
Jacinthe	p. 7, 15
Ku-Zee	p. 15
Mi Amigo	p. 21
Moulouk	p. 6
Moumou	p. 39
Noba	p. 18
Ortino	p. 36
Pepe	p. 21
Peps	p. 6
Peter	p. 36
Pohl	p. 6, **8**
Robber	p. 6
Rumpel	p. 6
Russ	p. 6
Zadig	p. 6, 11, 32

Acknowledgement

In memory of Michel Paris.

Many thanks to Madison Cox, and to the team at Musée Yves Saint Laurent Paris.

as well as to

Nastasia Alberti
Mark Alizart
Jean-Louis Andral
Emmanuel Bailly
Laurence Benaïm
Serena Bucalo-Mussely
Luc Castel
Olivier Chatenet
Clémentine Cuinet
Nathalie Daviet-Théry
Marie Delas
Dominique Deroche
Domitille Eblé
Dorothée Fabre et la Centrale canine
Matthieu Flory
Christophe Girard
Emma Gourault
Virginie Hagelauer
Dominique Haim
Charles Hascoët
Jean-Luce Huré

Elsa Janssen
Julia Karrer
Danielle Leclerc
Pierre-Emmanuel Martin-Vivier
Mouna Mekouar
Marine de Miollis
Damien Mougin
Philippe Mugnier
Elisa Nouaille
Annalisa Pagetti
Olivier Saillard
Bernard Sanz
Victor Serezal
Alexis Sornin
David Teboul
Cécile Verdier

 This publication is supported by the La Petite Escalère endowment fund.

Photo credits

Despite extensive research, we were unable to identify certain photographers.
Every effort has been made to cite the correct sources and respect copyright.

7h. © Roger-Viollet / Roger-Viollet
7ml. © Man Ray 2015 Trust / Adagp, Paris, 2024
7mr. © Granger / Bridgeman Images
7br. © PA Images / Alamy Banque D'Images
8hl. © Everett Collection / Bridgeman Images
8md. © Museo Nacional del Prado, Dist. GrandPalaisRmn / image du Prado
8bg. © GRANGER - Historical Picture Archive / Alamy Banque D'Images
9hg. © Centre Pompidou, MNAM-CCI, Dist. GrandPalaisRmn / image Centre Pompidou, MNAM-CCI © Adagp, Paris, 2024
9md. © incamerastock / Alamy Banque D'Images
9bd. © Cyrille Cauvet Théâtre de l'Incendie
14. © Collection Brigitte Mathieu Saint Laurent
16. © Christie's Images / Bridgeman Images
17. © Artcurial Beurret Bailly Widmer
19. © Robert A. Freson
20, 22, 23, 28—29, 33, 38, 43, 56, 79. © Tous droits réservés
25. © Martine Franck / Magnum Photos
26. © Roger Gain
30—31, 64, 67, 74—75. © Fondation Pierre Bergé-Yves Saint Laurent
34, 35, 41. © Patrice Habans
44. © Pierre Boulat / Association Pierre and Alexandra Boulat

45. © The Andy Warhol Foundation for the Visual Arts, Inc. / Licensed by Adagp, Paris, 2024
47. © Tous droits réservés © Yves Saint Laurent
48. © Horst P. Horst / Condé Nast via Getty Images
49. © Bettina Rheims
50—51. © Jean-Claude Deutsch / Paris Match / Scoop
52. © Fondation Pierre Bergé-Yves Saint Laurent © The Andy Warhol Foundation for the Visual Arts, Inc. / Licensed by Adagp, Paris
53, 54, 62hg. © Yves Saint Laurent
58. © Thierry Chomel
59, 62hd. © Alexandra Boulat / Association Pierre and Alexandra Boulat © Yves Saint Laurent
60—61. © David Teboul
62b, 65. © Alexandra Boulat / Association Pierre and Alexandra Boulat
68, 71. © Luc Castel
69. © David Hockney
70. © Christie's
73. © Musée du Louvre, Dist. GrandPalaisRmn / Philippe Fuzeau

© Adagp, Paris, 2024: Dora Maar, Man Ray, Andy Warhol

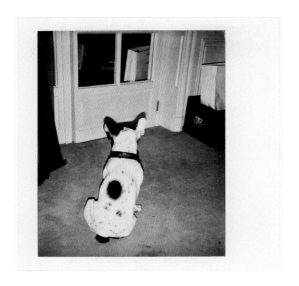

Moujik III, Avenue Marceau studio, Polaroid
taken by the fashion house staff, 2000s

Forthcoming

Joan Mitchell *and her dogs*
Peggy Guggenheim *and her dogs*
Andy Warhol *and his dogs*
Pierre Bonnard *and his dogs*

Series editor
Martin Bethenod

Editorial coordination
Virginie Hagelauer
With the assistance of Elisa Nouaille
and Emma Gourault

Page layout and drawings
Annalisa Pagetti

Revision
François Grandperrin

Translation from French
Alexei du Périer

Proofreading
Ben Young and Helen Bell

Photo-engraving
Graphium

ISBN : 9782376660989

© 2024 Éditions Norma
149, rue de Rennes,
75006 Paris, France
www.editions-norma.com

Printed in October 2024
by Graphius, Belgium

Couverture :
Yves Saint Laurent, "Love" greetings card
(with Moujik IV), 2006, detail